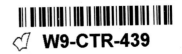
Ira Yeager: Indian Paintings

FORTY YEARS OF INDIANS

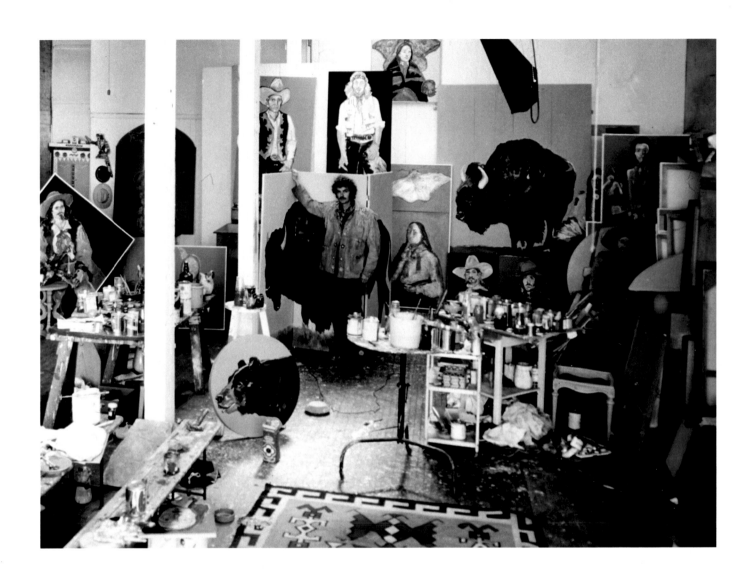

Powell Street Studio, 1967

Contents

Foreword

Nearly 17 years ago on a warm summer evening, I accepted a gracious invitation to "Appel Mählen," a previously abandoned 17-acre heirloom apple orchard in the foothills of the Napa Valley where Ira Yeager calls home to one of his inspiring Northern California studios. Upon my arrival, I wasn't positive that I entered the correct gate per the directions offered earlier that day. With fear of possibly offending an unsuspecting landowner who wasn't expecting guests, I left my car by the edge of the road and started on foot about the property in search of the Adirondack-inspired barn that was described as my destination. The approach led me to what appeared to be two gate cottages or guest quarters. On down the drive and approaching the second dwelling, I began to hear what I later found to be a guest resident of the cottage rehearsing a Puccini opera.

In search of a painter's studio, and not an impromptu concert, I decided to proceed up the winding road that thankfully started feeling more like those deposit-slip sketched directions I had jotted down earlier. Now continuing with a bit more confidence, my ears once again became my guide. The Puccini seamlessly became classic Maria Callas at concert levels. There seemed to be a theme here. Just as I could re-orientate myself, a glimpse of the glowing three-story building appeared through the flowering Mimosa trees ahead. A figure briefly appeared in the open balcony, waving me up with a welcoming confidence. As I finally approached the studio, I was greeted not by my host but instead by an exhibition of what seemed like a tribe or delegation of large Indian portraits leaning four-wide against the rustic barn siding, as well as a collection propped up by a perimeter of old, gnarled heirloom apple trees that resembled totems dotting the landscape. Pausing a moment to absorb this unexpected reception, I was surprised yet again by another very large painting that appeared to be on the move and with a voice. "What do you think of this beauty?" boomed the greeting, resounding over the aria that still poured from the open windows, stories above.

With great honor, I finally have an opportunity to truly answer that telling question.

Wisdom and beauty are things that I believe still abound if one knows where to look. Some may be able to give you a learned definition, but most could not give you a promising source. The day I was welcomed to Apple Mahlen, I truly believe I was introduced and set on a path on how to be a student of true beauty as well as how to recognize trusted sources of wisdom. The opera that greeted me that day at first simply resembled a possible muse, but now, I know its true place in the life of this artist. Surrounding oneself with joy and beauty is what I have found to be at the core of the philosophy and life of Ira Yeager. This series of Indian paintings that Ira Yeager has been returning to since the mid-1960s exemplifies my conviction. The collection of regal paintings that welcomed me to the "World of Ira Yeager" also clarified that to know his work is to truly know the artist.

Within the following pages, it is my true hope you will also discover this wisdom and beauty I have found through this, his distinctive process of bending abstraction into figuration.

BRIAN FULLER, director
Ira Yeager Studios

Native-Born Nobility

"Good words do not last long unless they amount to something. Words do not pay for my dead people. They do not pay for my country, now overrun by white men.

Good words cannot give me back my children. Good words will not give my people good health and stop them from dying. Good words will not get my people a home where they can live in peace and take care of themselves.

I am tired of talk that comes to nothing. It makes my heart sick when I remember all the good words and all the broken promises. There has been too much talking by men who had no right to talk. It does not require many words to speak the truth."

CHIEF JOSEPH, 1840–1904
known by the Nez Perce as In-mut-too-yah-lat-lat
(Thunder coming up over the land from the water)

The melancholy history of the American Indian over the last three centuries is all too well known. Through the introduction of foreign diseases, systematic genocide and relentless geographical marginalization, European colonies and later the manifest destiny of Americans reduced the once mighty family of Indian nations to near extinction. Their exploitation has been the subject of volumes of authoritative histories and is not in dispute. It is a sad chapter in the history of our country. That this body of moving images of Native Americans was created over the past 40 years by this artist is both surprising and understandable.

Ira Yeager was perfectly situated to take advantage of a defining moment in the history of Bay Area art when he started his art training at the California College of Arts and Crafts in 1957, followed by time at the San Francisco School of Fine Arts in 1959. Figuration, inspired by the energy of abstract Expressionism, was being transformed by Richard Diebenkorn, Elmer Bischoff and Nathan Oliveira into a dynamic new way of responding to the world around us. Through their teaching and by their example, Yeager came into his own as an artist. By the time he left for further study in Italy in 1960, Yeager's course was set as one who took

advantage of exuberant color, bold composition and painterly application to form his distinctive artistic voice.

A world traveler who has spent extended periods of time in Italy, Greece and New York, Yeager is famous for his ability to transform his love of the eighteenth century into a twentieth-century equivalent of Mozart's music, containing humor, sweetness, formality and grandeur.

There is, however, another side of Ira Yeager. He has never forgotten that he is a Westerner. Born in Bellingham, Washington, he is related to a distinguished family of early settlers of the state. Their claim to fame was as outfitters to generations of explorers and sportsmen in an era when the divide between civilization and wilderness was more clearly defined.

In the mid-1960s, Yeager's natural wanderlust led him to Santa Fe, New Mexico, and while there he commenced an artistic dialogue that has continued unabated to the present day: his masterful series of Indian portraits. Large (rarely less than four by four feet), frontal, and often disturbingly direct, Yeager usually concentrates solely on the faces of his subjects adorned with their ceremonial trappings. The appearance of feathers, beadwork and fabric allows Yeager to display his bold yet balanced application of color. With often vibrant, solid color or patterned backgrounds, they command attention.

Despite their technical brilliance, it is not so much what you see in them but how you feel about them that transforms these painted renderings into deeply moving portraits. They display stateliness, wisdom and a sense of history measured by loss in their stoic and furrowed faces staring out at us. Yeager's paintings are in the tradition of late nineteenth and early twentieth century photographers such as F. Jay Haynes, Frank A. Rinehart and Edward S. Curtis, who admirably portrayed the Native Americans they photographed with a quiet dignity that continues to be compelling even today.

In his Indian paintings, Ira Yeager allows his humanity as an artist to shine through without sentimentality but with a profoundly moving display of character and gravitas. These paintings, of course, cannot undo or make up for the wrongs inflicted on Chief Joseph and countless other Native Americans, but they serve to remind us of an often-underemphasized aspect of who we are and where we come from as Americans that should never be forgotten.

ROBERT FLYNN JOHNSON, curator in charge
Achenbach Foundation for Graphic Arts, Fine Arts Museums of San Francisco

Consider in this light, within Yeager's work, the monumental American Indian heads, and we can see how the play of line and form enhance the heroism, the nobility, of these great monolithic figures. These figures, representative of a lost grandeur, sway into historical significance. And then observe the slightest drop, or freezing, of the rhythm around the chin, the tightening, or slackening, of the contour, and we start to ask ourselves whether there is not some inner despair here, some flaw-line that runs through all this outward optimism, and that turns these iconic images into records of inner trouble. Yeager gets us to ask, Is their defiance of the world in part an admission of defeat?

RICHARD WOLLHEIM

Indian Portrait

2000; *oil and acrylic on canvas*
48 x 48 inches

Private Collection

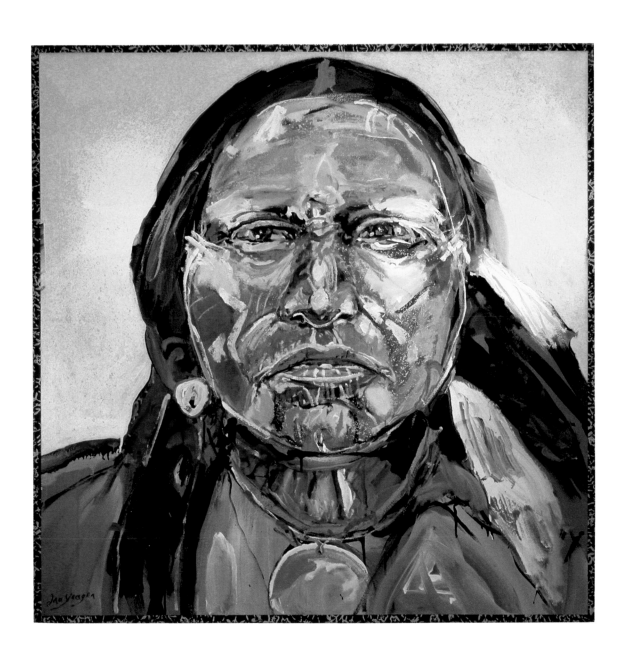

"The days and nights are spent in singing and dancing.
The singers squat on the ground beside the buffalo-skin
drums and beat on them, and while they sing the others
dance. Some are dressed like buffalo, some like bears,
some like eagles, and many like other beasts and birds."

Indian Portrait: Bison Bison Americanvs

2004; *oil and acrylic on canvas*
48 x 48 inches

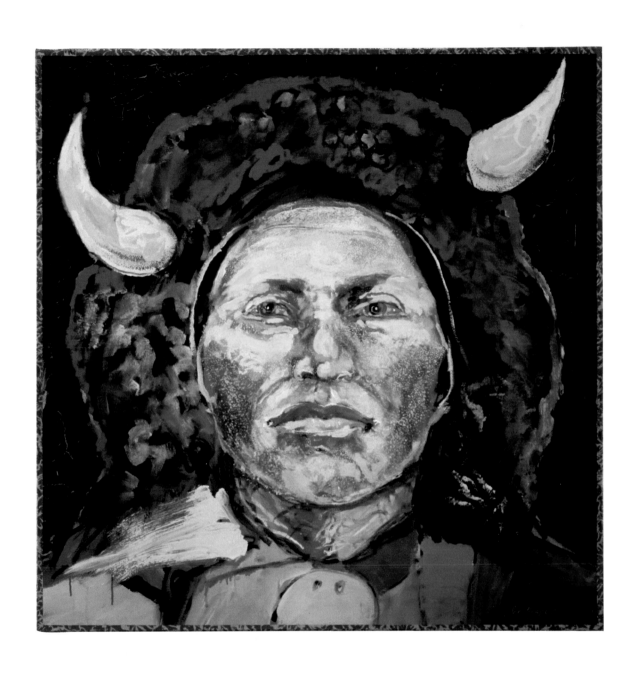

Indian Portrait with Wolf Headdress
2004; oil and acrylic on canvas
66 x 66 inches

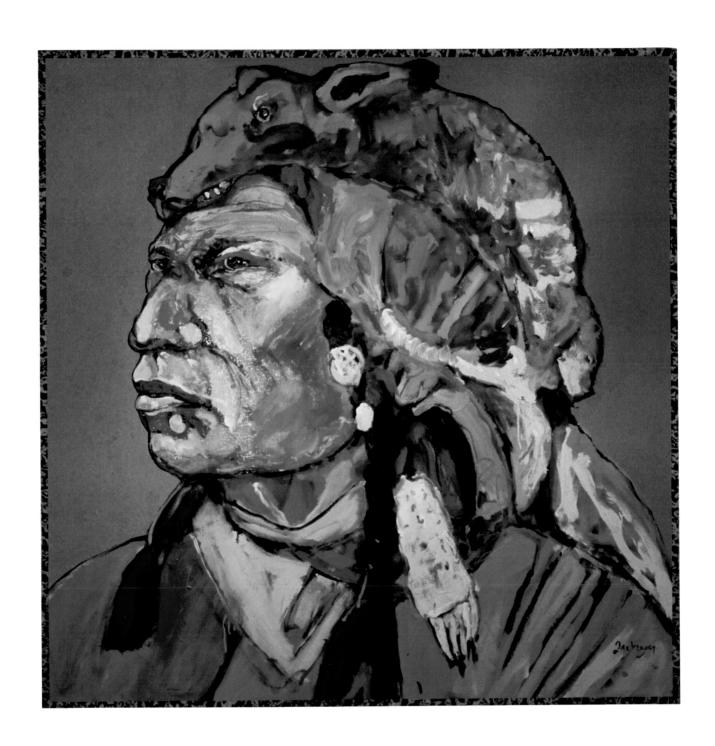

Indian Portrait: Plumed Headdress
2005; *oil and acrylic on canvas*
48 x 48 inches

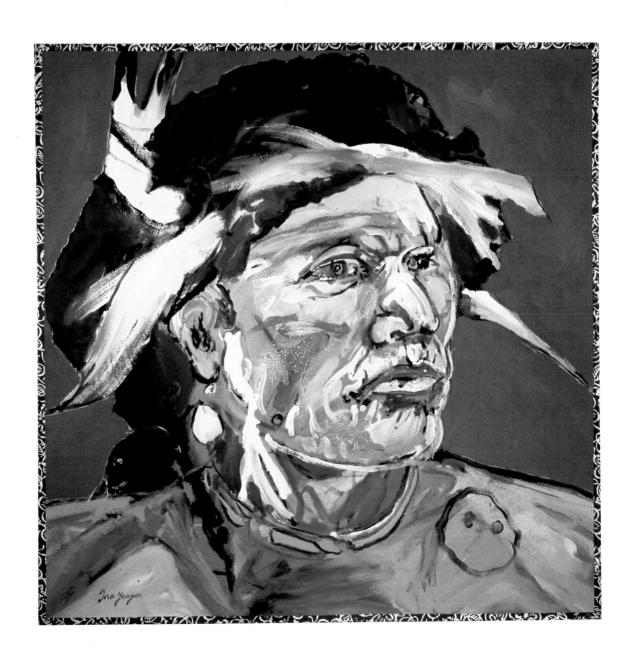

"First the proud chiefs stalked in. Nearly all were wrapped with robes of buffalo, some with the hair outside, others with the smooth skin out and the hair next their bodies. Many of these robes had decorations of gaily colored porcupine quills sewed upon the smooth surface. Others were painted in a way that told the story of the warrior's fasting and battles."

Indian Portrait: Chief with Headdress
2005; *oil and acrylic on canvas*
60 x 60 inches

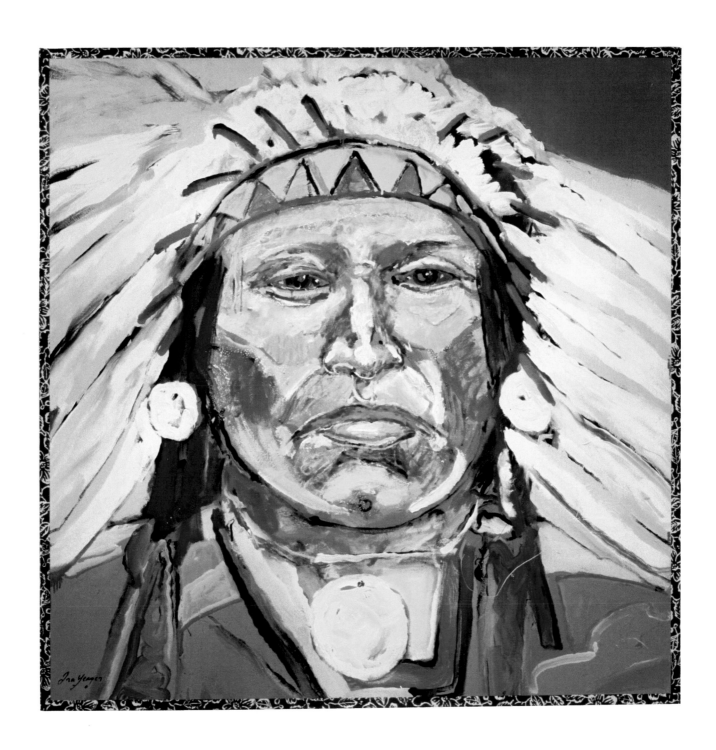

Indian Portrait: Chief with Headdress

2006; oil and acrylic on canvas
60 x 60 inches

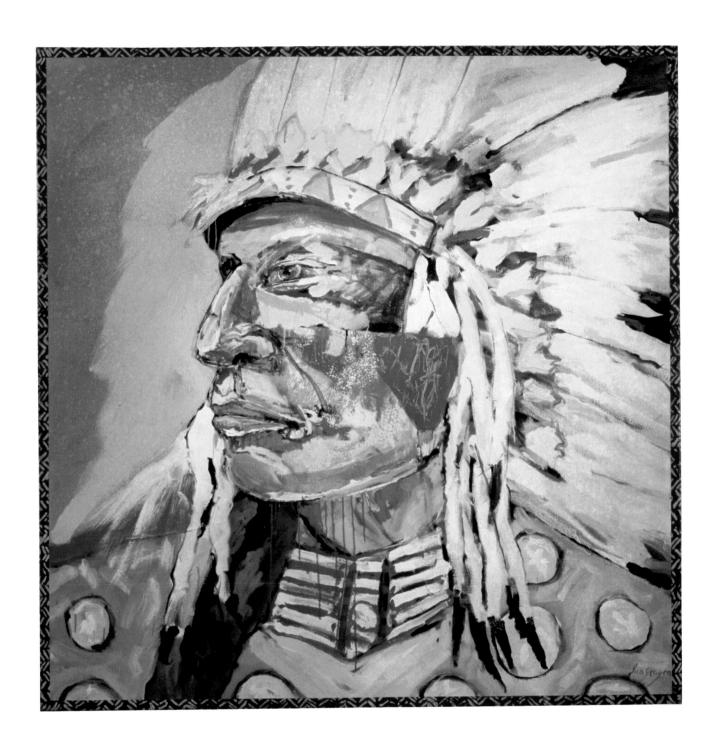

Indian Portrait: Chief with Headdress
2004; oil and acrylic on canvas
60 x 60 inches

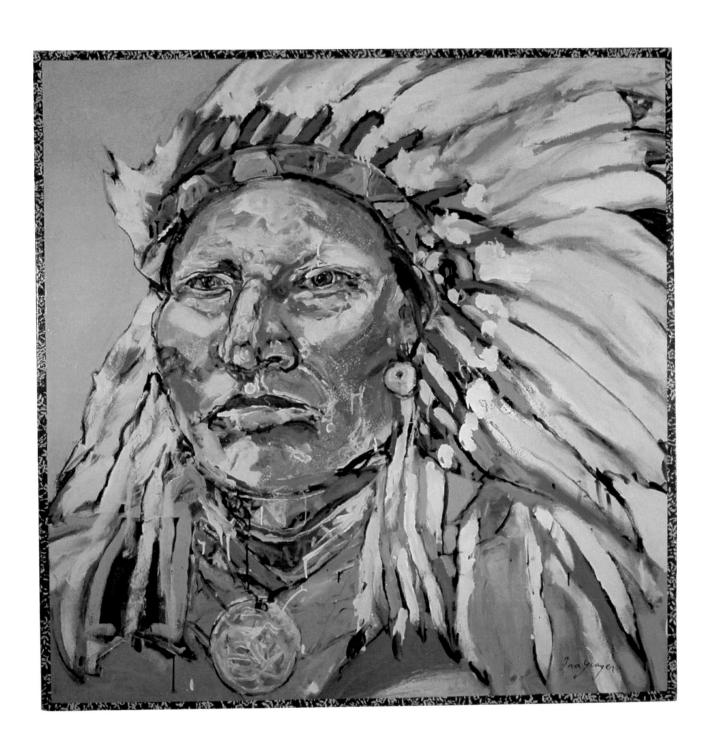

"Thus the mode of the Apple Malen fog, from which appear a legion of ancient warriors, old Indians dressed up like ladies from a Versailles garden. The entire lexicon of powdered up old Bad Boys who became fat and old, their centers of gravity evolving slowly from their Bad Boy Brain down into their amassing Bad Boy Bellies...This metamorphosis from summer dragonfly into a wrinkled sleepwalker from the wings of Turandot, old powdered boys with hideous black 'beauty' spots arising from their white masks like spots on a leopard. Oh, yeah, that's what we mean by 'artistic,' the cast of characters. The 'deja vue' teapots – wasn't that Uncle Horace or maybe old Earl Grey, no doubt...And all of them going on in Italian, Italian, Italian about the 'kingdom of love' or some such, all of them gliding out on an Apple Malen foggy morning."

TEDDY WILLIAMS
Le Chateau Morsan
Morsan, France

Indian Portrait: Fraternus Amor Maneto
2001; *oil and acrylic on canvas*
48 x 48 inches

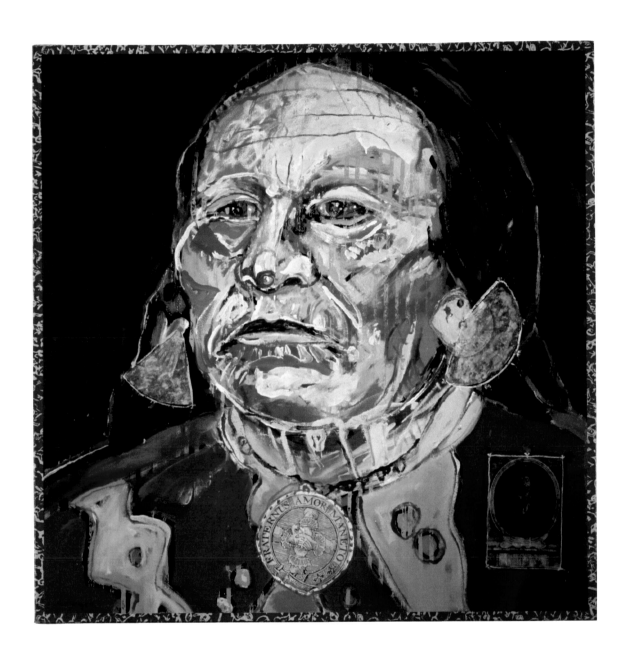

Indian Portrait

2005; *oil, acrylic and gesso on canvas*
60 x 60 inches

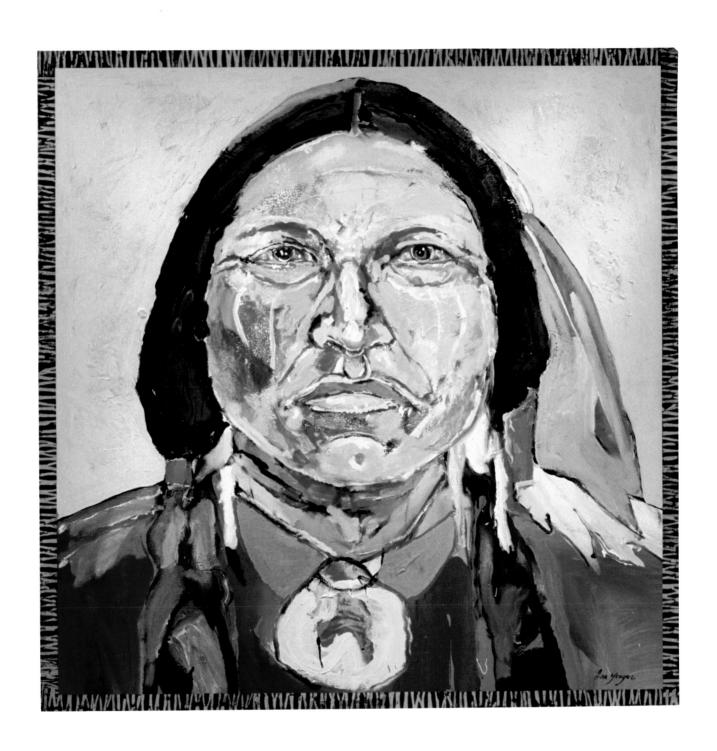

Indian Portrait: Seminole Painting
2001; *oil and acrylic on canvas*
48 x 48 inches

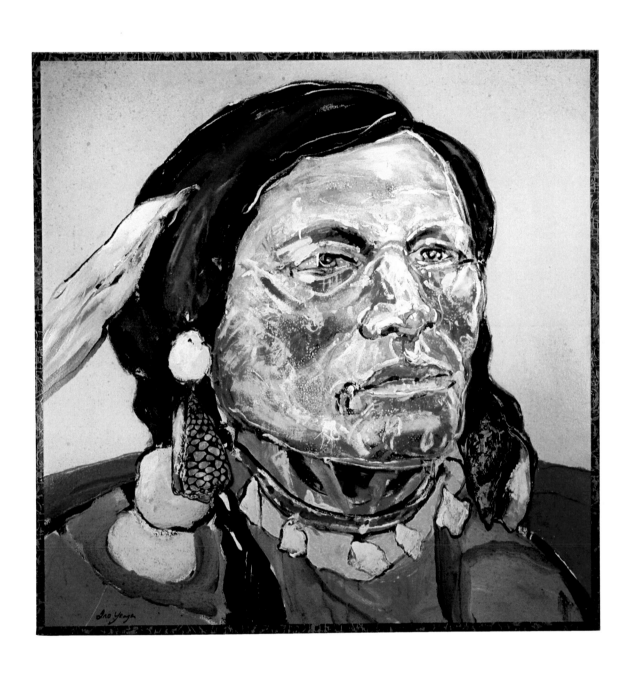

"Black Eagle, slowly and with deliberation, stood upon his
feet. His height was the breadth of a hand more than that
of the others. On his head was a close-fitting, crestlike cap
made from an eagle skin, and wrapped close about him was
a robe of the buffalo. As he rose, the robe was thrown off,
and he stood before his fellows like a bronze statue."

Indian Portrait

1997; *oil and acrylic on canvas*
48 x 48 inches

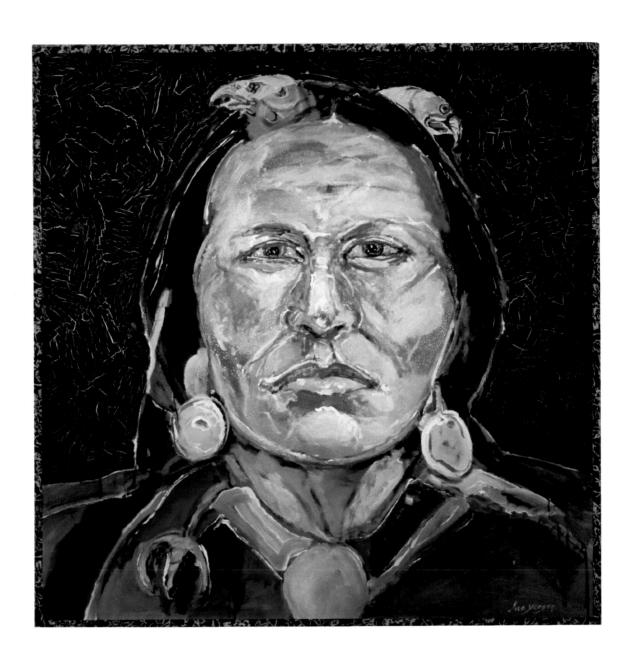

Indian Portrait

1996; *oil and acrylic on canvas*
48 x 48 inches

Collection of Mr. and Mrs. Norman Wohlken

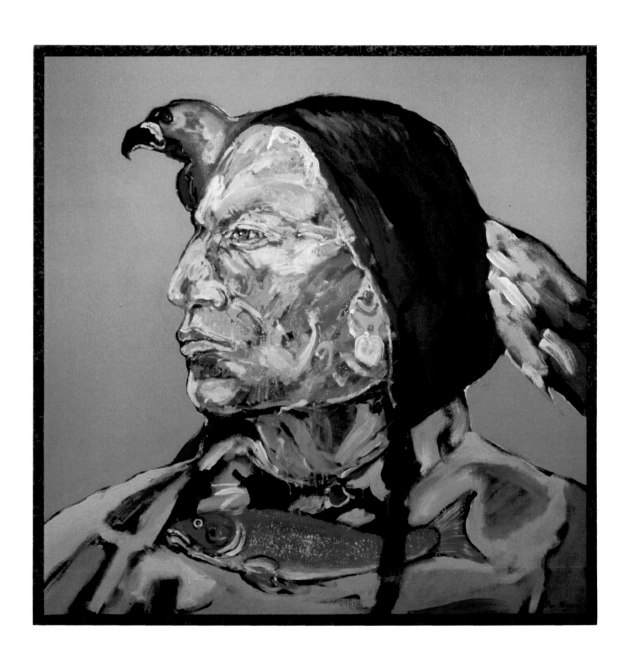

Indian Portrait with Snow Owl Headdress

2001; *oil and acrylic on canvas*
48 x 48 inches

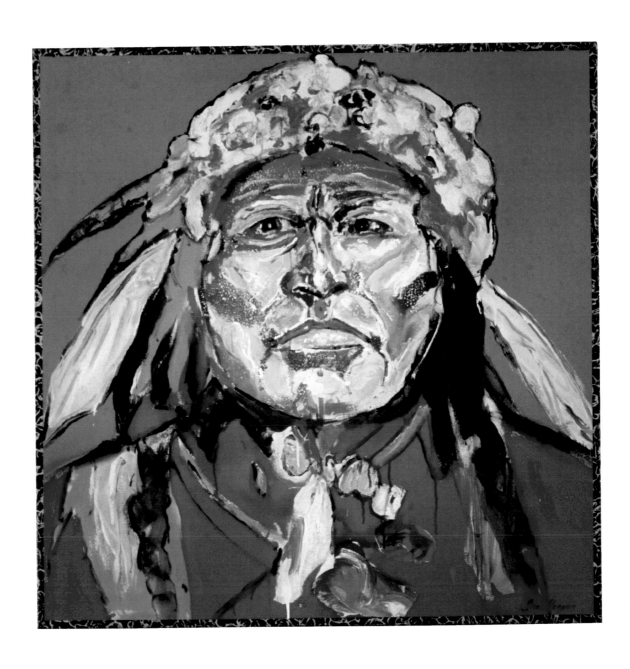

Indian Portrait: Une Première Migration
2006; *oil and acrylic on canvas*
36 inches diameter

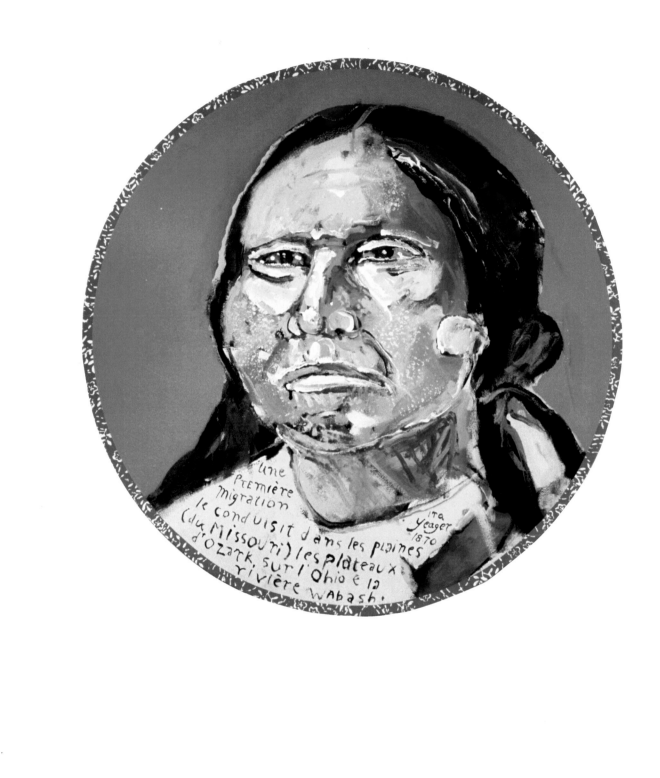

une
première
migration
le conduisit dans les plaines
(du Missouri) les plâteaux
d'Ozark sur l'Ohio e la
rivière Wabash.

Ira
Yeager
1870

"Salish brothers, the words we have heard tonight bring to
my eyes many strange and wonderful pictures. But they
make my heart very sad and heavy, for they show that a
new people with strange words and thoughts are creeping
upon us, and, like old age, nothing can stay them."

Indian Portrait
2001; *oil and acrylic on canvas*
48 x 48 inches

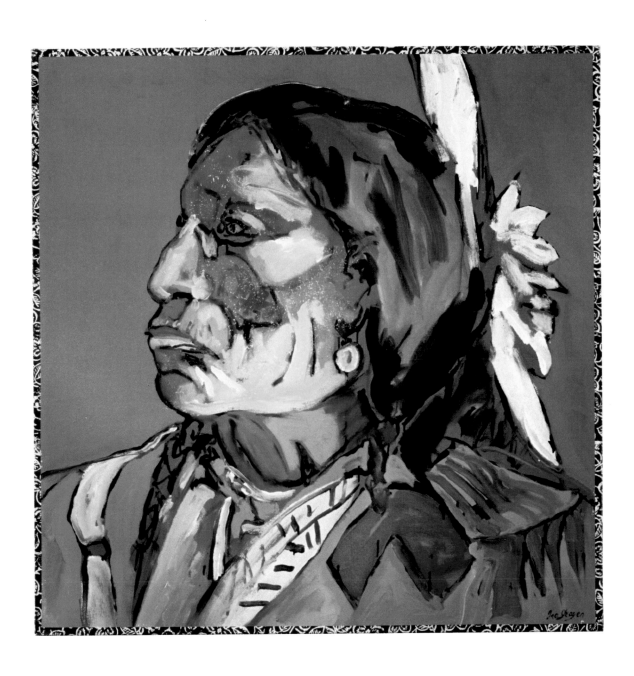

Indian Portrait: Chief with Headdress
2005; oil and acrylic on canvas
66 x 66 inches

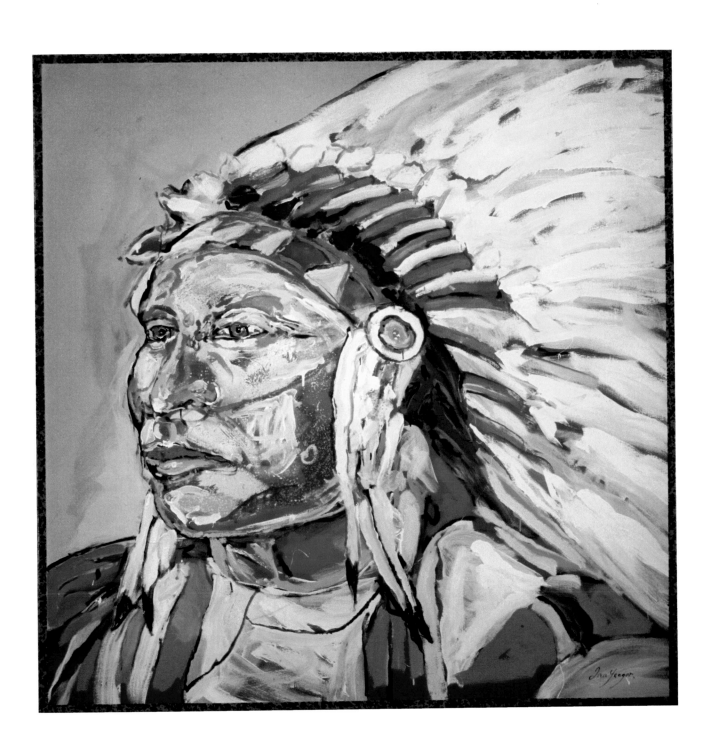

"In the beginning of the world, they say, there was but one man on the earth, and the name by which they call him is One Man. The ground was not yet hardened, and in order not to break through the crust he had to run quickly. He it was who created rivers, lakes, springs, hills, and trees, making the earth ready for the people who were to come."

Indian Portrait en fleur avec poisson
2000; oil and acrylic on canvas
66 x 66 inches

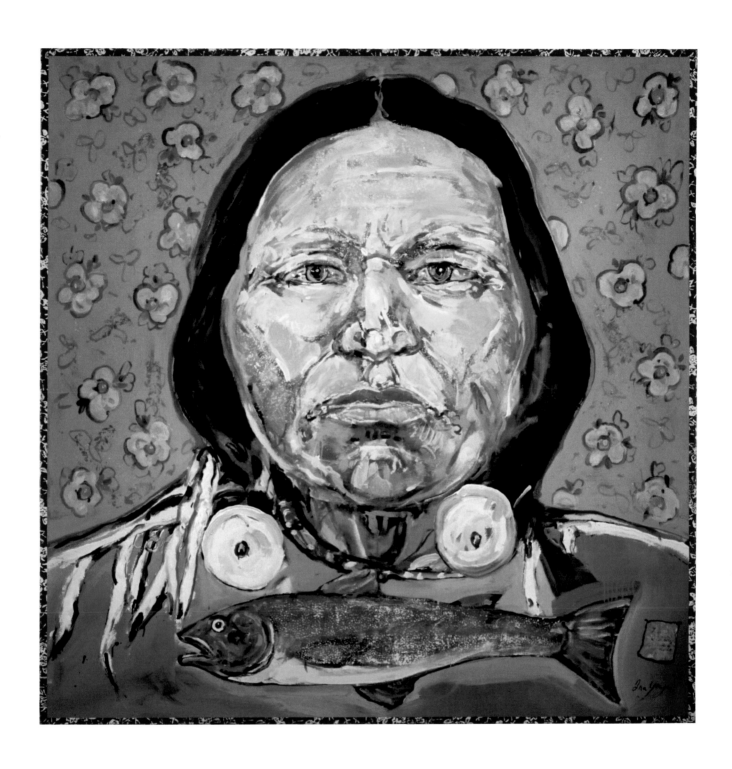

Indian Portrait with Ermine Headdress
1991; *oil and acrylic on canvas*
48 x 48 inches

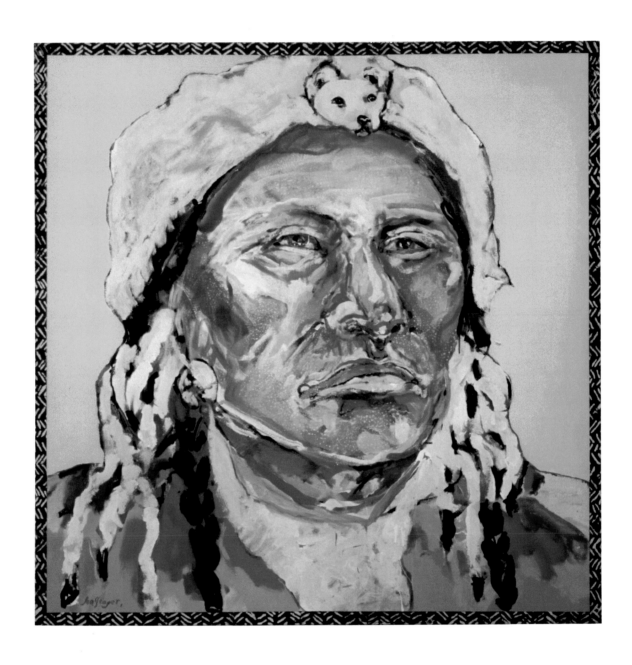

"My children, as we travel the long trail through life,

we find that there are sad as well as happy times."

Indian Portrait with Headdress

1993; *oil and acrylic on canvas*

48 x 48 inches

Collection of Mr. and Mrs. George and Brenda Jewett

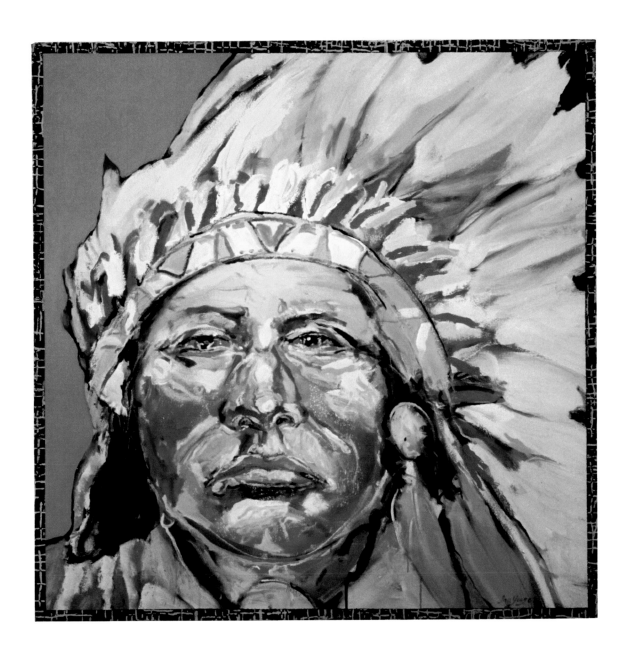

Indian Portrait

2006; *oil and acrylic on canvas*
48 x 48 inches

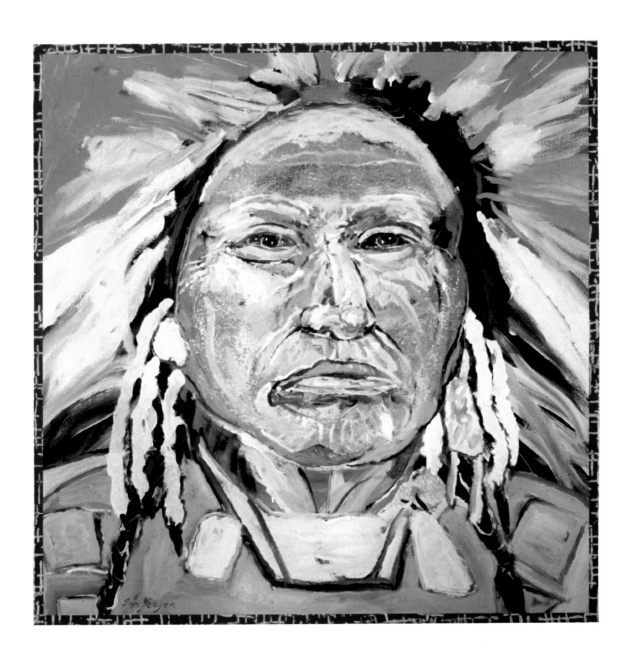

"As the trail approached a deep, quiet pool in the river, Kukúsim whispered, 'Here lives the Father Fish of the river.'"

Indian Portrait with Fish Headdress
2003; *oil and acrylic on canvas*
48 x 48 inches

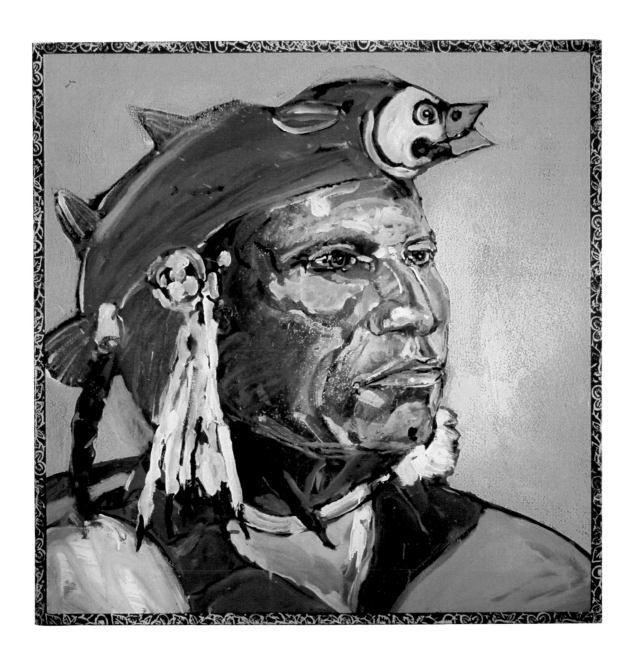

**Indian Portrait with Ermine and
Eagle Headdress and Ravens**

2001; *oil and acrylic on canvas*
48 x 48 inches

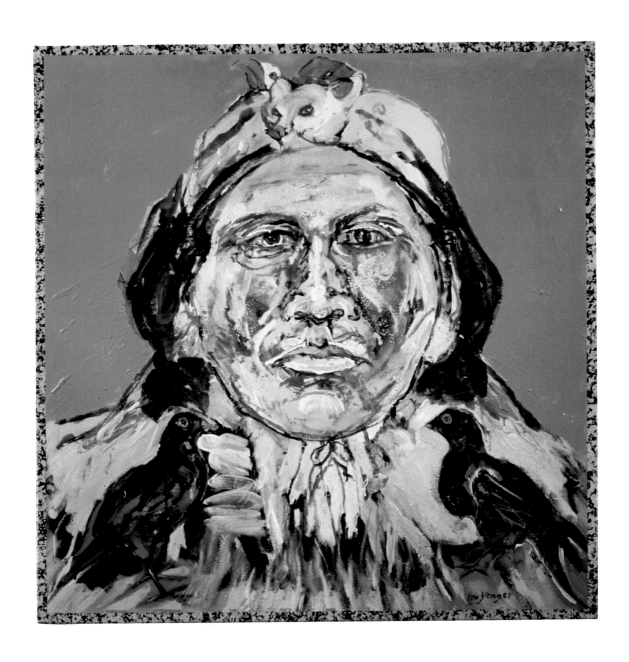

"You are shooting up like the willows. You are becoming a man.
It is time that you look for the voices of the darkness and get
something that will make you a strong warrior and a wise chief."

Indian Portrait

1997; *oil and acrylic on canvas*
24 x 24 inches

Private Collection

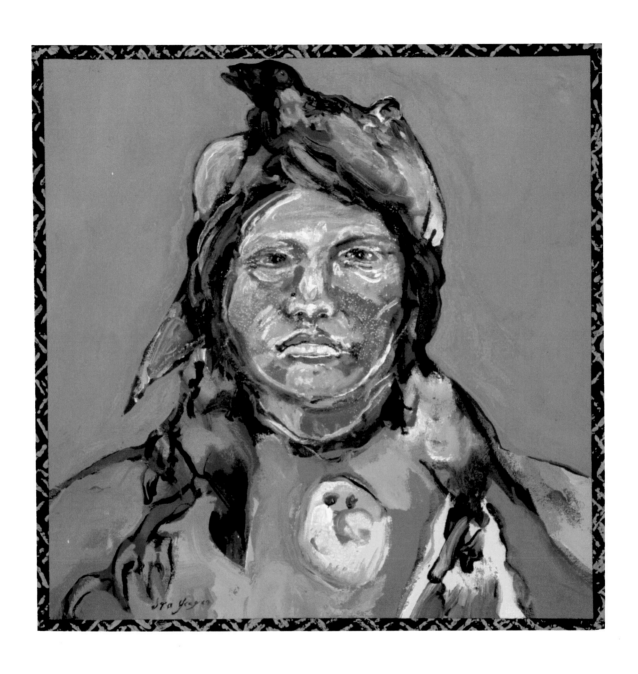

Indian Portrait: Territory l'Oklahoma 1852.
2006; *oil and acrylic on canvas*
60 x 60 inches

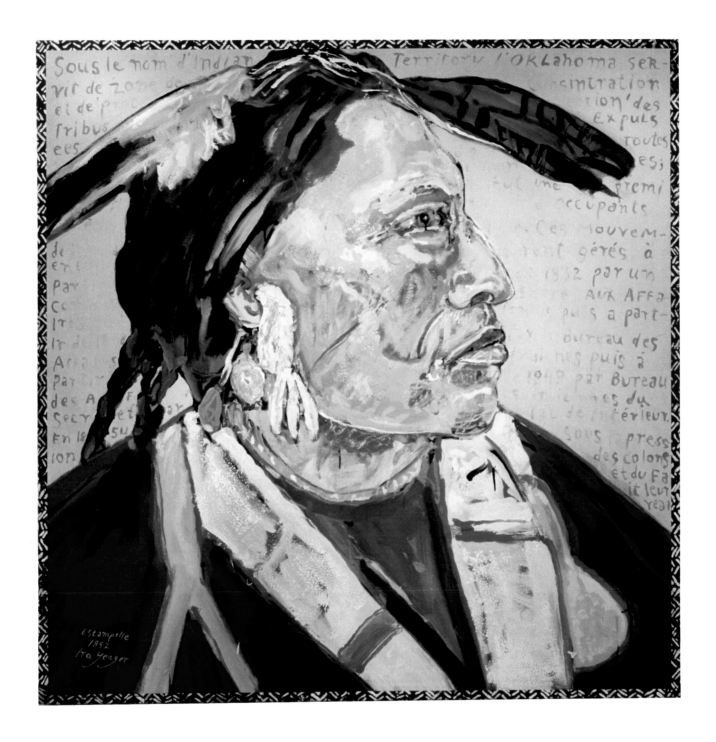

"His courage in battle brought him many honors."

Indian Portrait

2006; oil and acrylic on canvas
66 x 66 inches

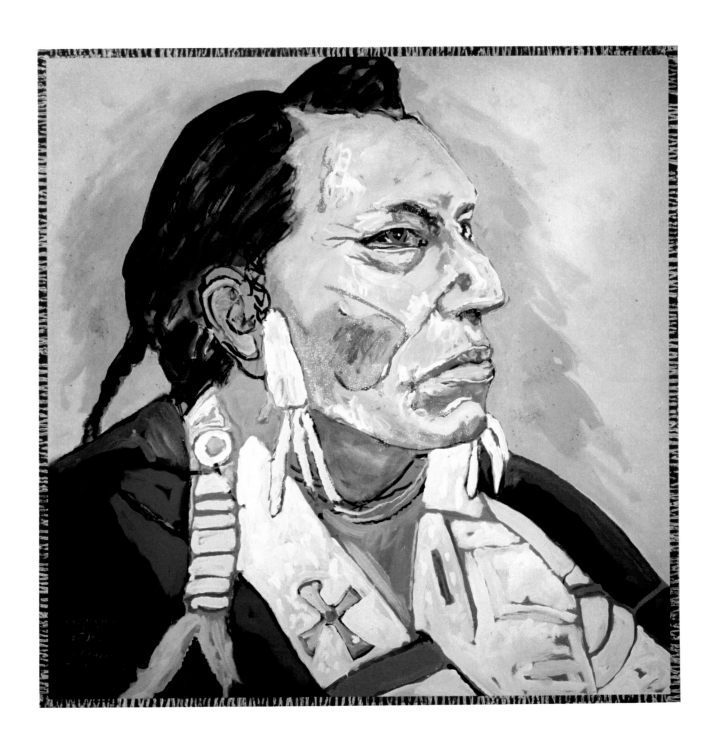

"'It is the way of our people not to show our heart to others,'" the old man explained. 'If we show the secrets of our heart, then is our spiritual strength broken. You are young and the thought is big, but it is like this: Within us, perhaps it is our heart, there is something white and pure, like the snowy down-feathers of the eagle. If we drag this pure feather about in the sight of others, or if we do wrong, the feather is soiled and black, and has no strength. It is the law of our inner self that if we take care of this feather, our footsteps lead us well…'"

Indian Portrait

1997; *oil and acrylic on canvas*
48 x 48 inches

Collection of Mr. and Mrs. Koerner "K.R." Rombauer

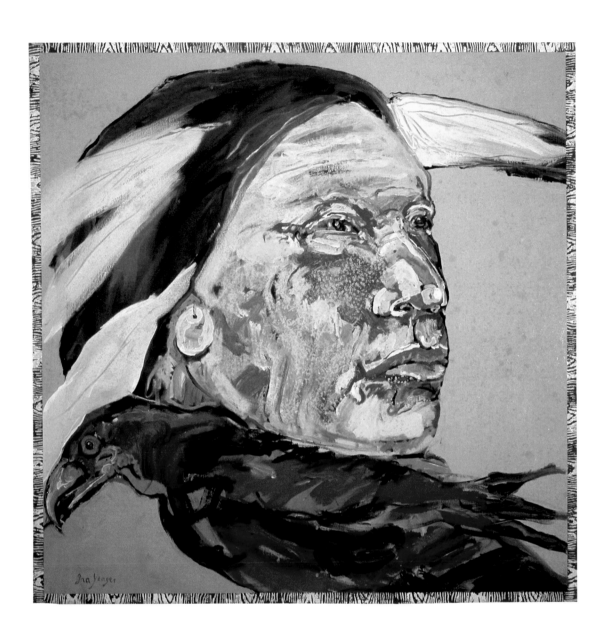

Indian Portrait: Chief with Headdress (Profile)
2005; oil and acrylic on canvas
48 x 48 inches

Collection of Mr. and Mrs. Ron McMicking

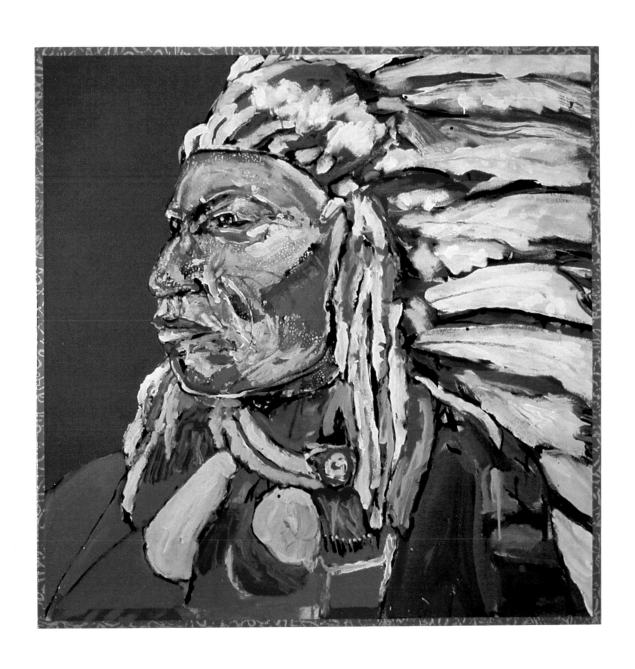

Indian Portrait: Chief with Headdress

1982; *oil and acrylic on canvas*
66 x 66 inches

Collection of Mr. and Mrs. Brian Fuller

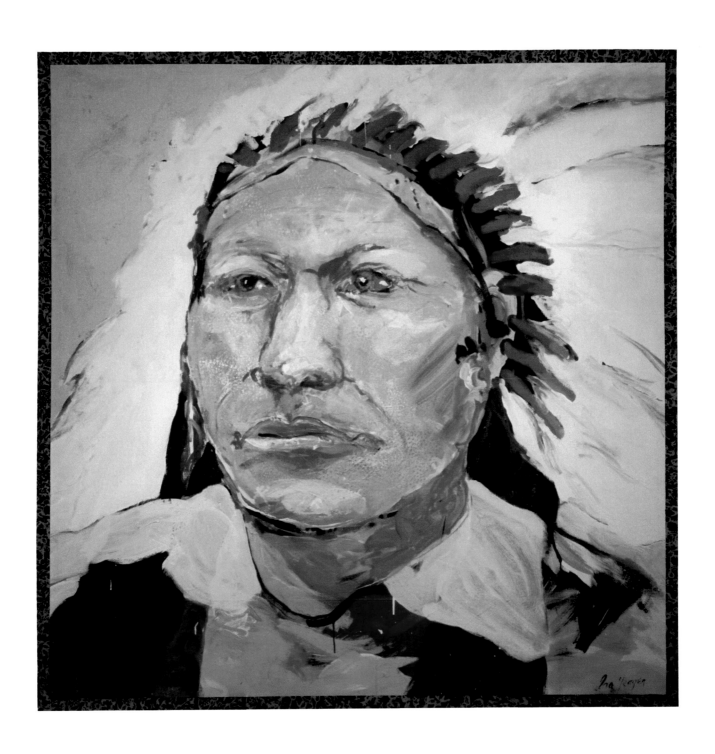

"He gathered wisps of long grass and tied them
in his hair in such a way that from a distance his
head and shoulders looked like a bunch of grass."

Indian Portrait: "Tribus de prairies"

2006; *oil and acrylic on canvas*
60 x 60 inches

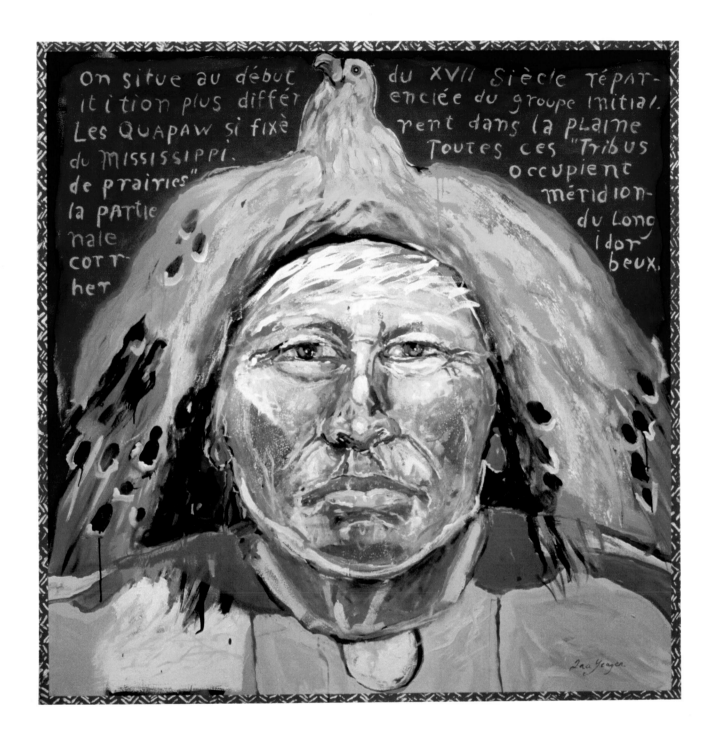

On situe au début du XVII Siècle répar-
it i tion plus différ enciée du groupe initial.
Les Quapaw si fixè rent dans la plaine
du Mississippi. Toutes ces "Tribus
de prairies" occupient
la partie méridion-
nale du Long
corr- Idor
her beux.

Indian Portrait

2006; *oil and acrylic on canvas*
48 x 48 inches

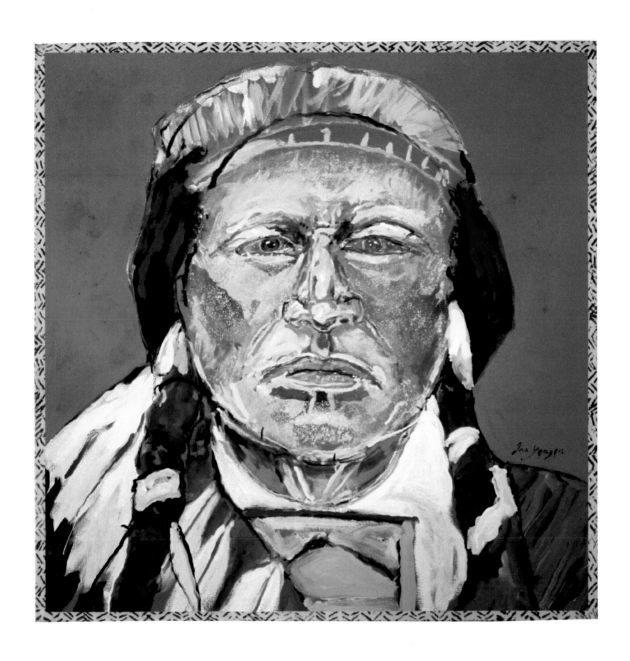

"His hair was oiled and combed, his whole body painted red.
Special attention was given his face, which was painted to
represent the sky at sunrise – yellow at the chin, and blending
through deep colors to a bright crimson at the forehead. In
his hair was a bunch of hawk feathers, and on his feet were
brown moccasins, and on his legs just below the knees were
bands on which were fastened many deer dew-claws. These,
when he danced, rattled in rhythm with the songs and drums."

Indian Portrait

2006; oil and acrylic on canvas
36 x 36 inches

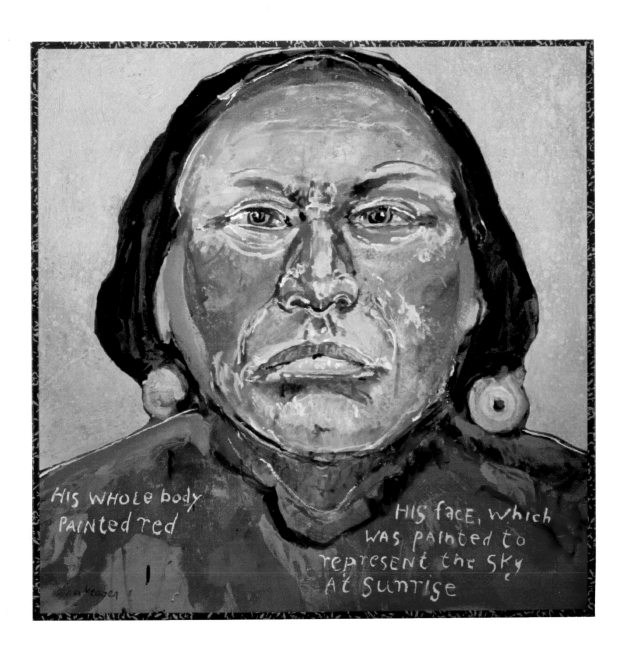

71

Indian Portrait

1999; *oil and acrylic on canvas*
48 x 48 inches

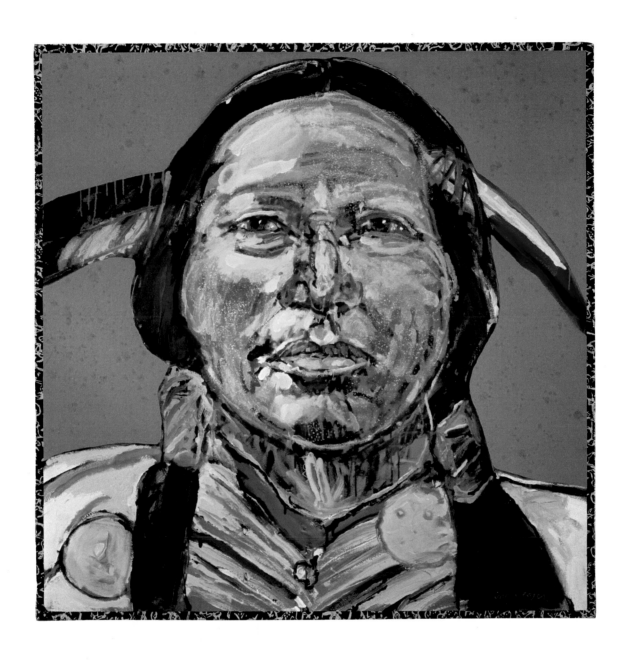

Indian Portrait

1994; *oil and acrylic on canvas*
48 x 48 inches

Collection of Ms. Emily Taylor

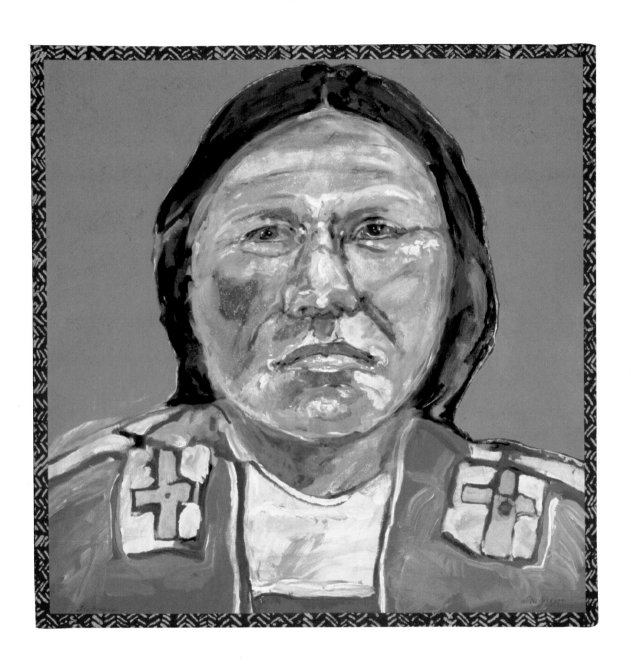

Indian Portrait

1989; *oil and acrylic on canvas*
48 x 48 inches

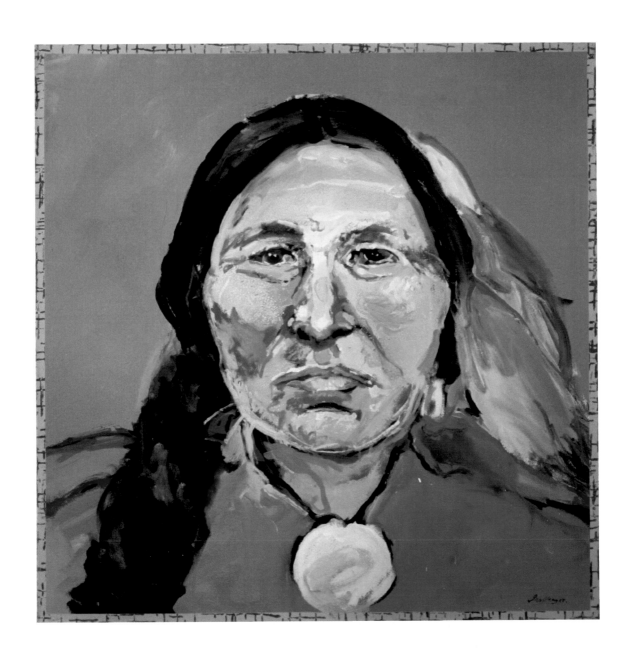

"...It could be plainly seen that he was a stranger
in the land. His face bore a keener expression. His
clothing was different, and instead of a full head of
hair with a long braid down each side, he wore but a
strip of bristling hair along the crown of his head."

Indian Portrait

1999; *oil and acrylic on canvas*
48 x 48 inches

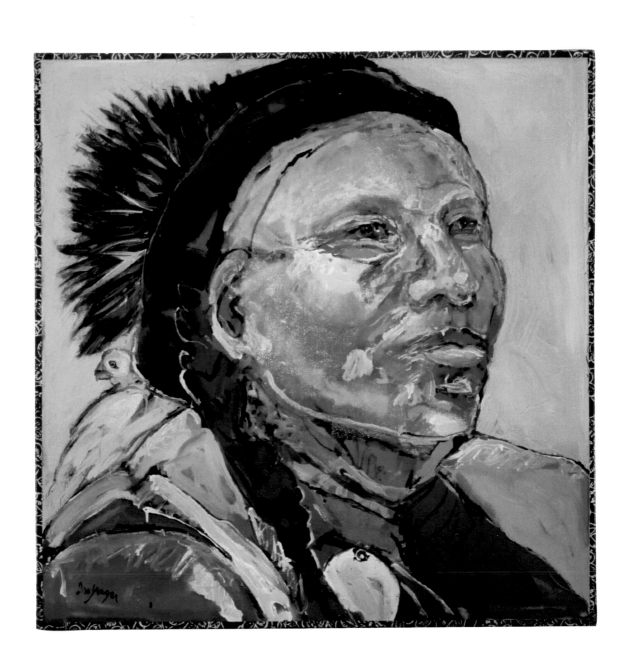

Indian Portrait and Fish
1995; oil and acrylic on canvas
48 x 48 inches

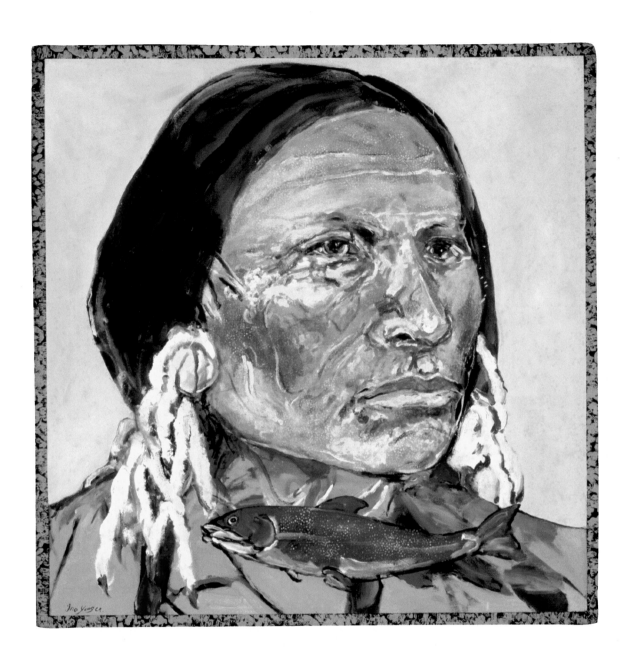

Indian Portrait and Rooster

1995; *oil and acrylic on canvas*
48 x 48 inches

Collection of Ms. Priscilla Jordan

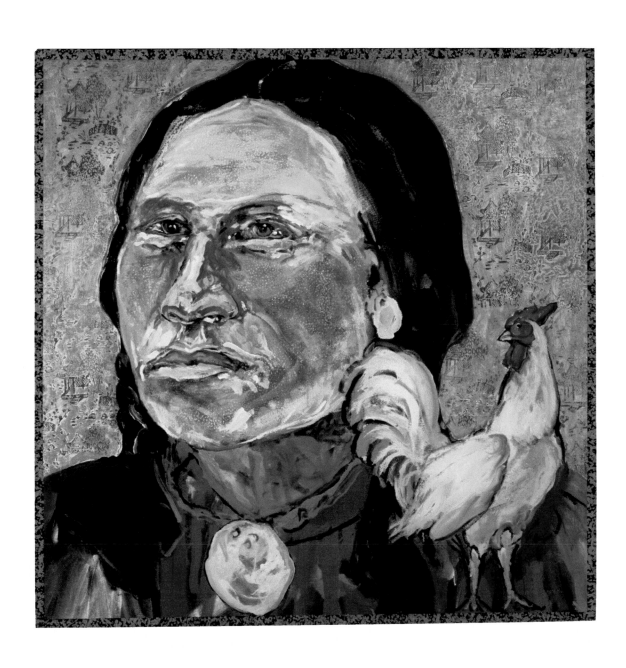

"My Father told me the trapping beaver men began to come to our village even when he was a little boy. Some of them lived among the people. Many of them married women of the people, and later even learned the tongues. More and more of them came, some for the beaver and others only for the talk."

ANONYMOUS

Untitled

1997; *oil and acrylic on canvas*
48 x 48 inches

Collection of Mr. and Mrs. William Fischbach

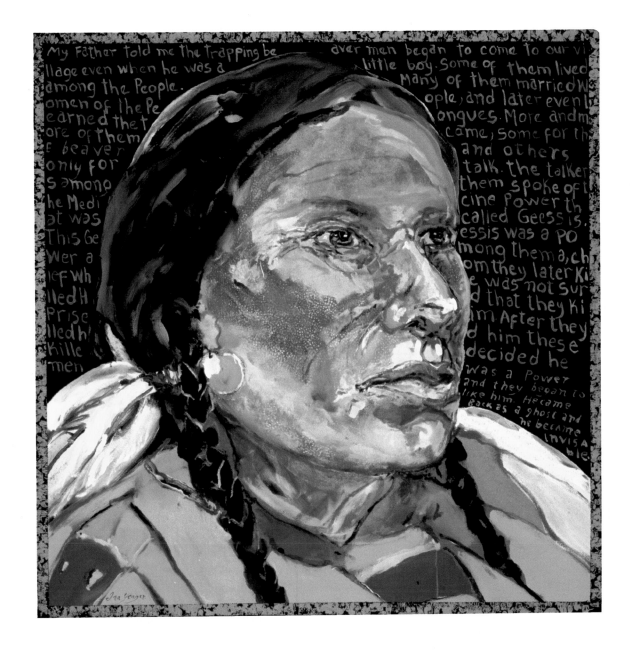

My Father told me the trapping be...ever men began to come to our vi
llage even when he was a...little boy. Some of them lived
among the People....Many of them married w
omen of the Pe...ople, and later even l
earned the t...ongues. More and m
ore of them...came, some for th
e beaver...and others
only for...talk. the talker
s among...them spoke of t
he Medi...cine Power th
at was...called Geessis.
This Ge...essis was a Po
wer a...mong them, ch
ief Wh...om they later ki
lled H...e was not sur
prise...d that they ki
lled h...im. After they
killed...d him these
men...decided he
was a power
and they began to
like him. He came
back as a ghost and
hi became
INVISA
ble.

Indian Portrait: Chief with Headdress
1996; *oil and acrylic on canvas*
48 x 48 inches

Collection of Mr. and Mrs. William Fischbach

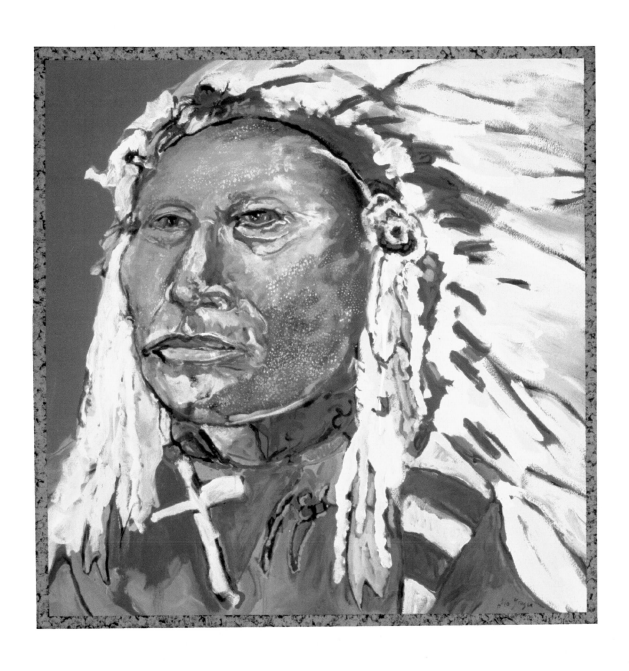

"I will teach you new songs and the ways of many warriors. And when your arm is strong enough to draw the man's bow, your father will know that you are wise and can proudly bear his name."

Indian Portrait: Brave (Profile)
1996; *oil and acrylic on canvas*
48 x 48 inches

Collection of Dr. and Mrs. Richard Grossman

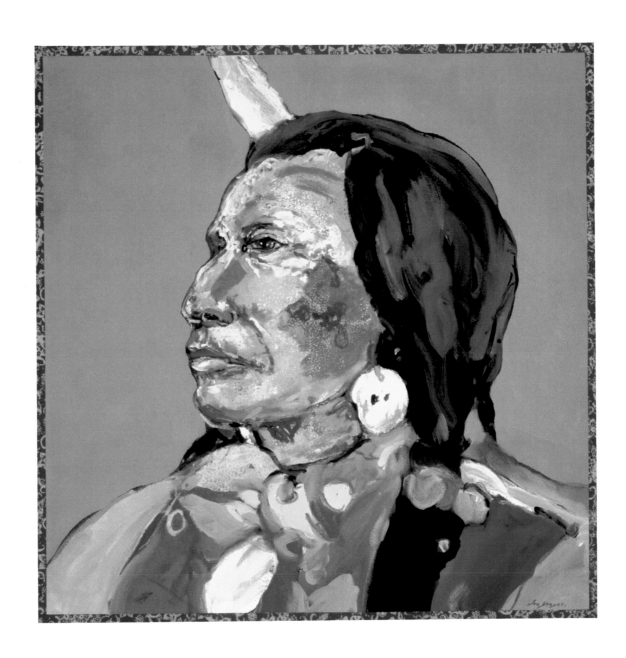

Indian Portrait: Chief with Headdress

1993; oil and acrylic on canvas

48 x 48 inches

Private Collection

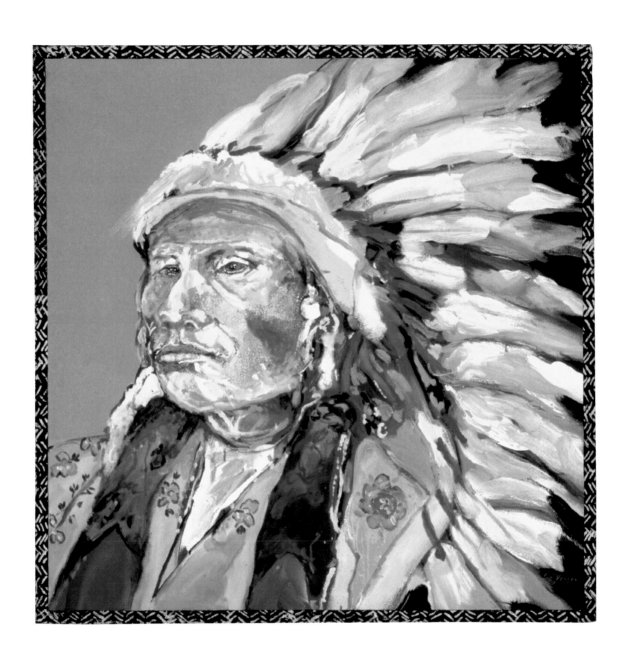

Indian Portrait with Buffalo Headdress
1992; *oil and acrylic on canvas*
30 inches diameter

Collection of Ms. Danielle Steel

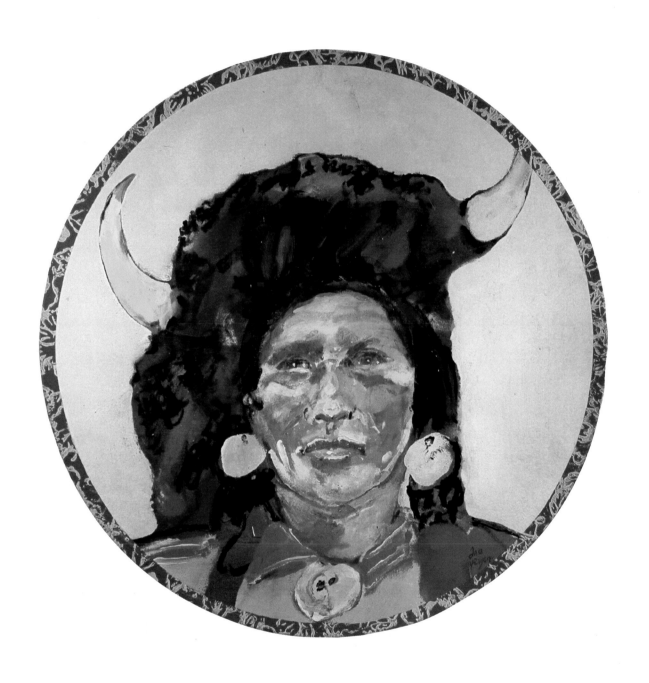

Indian Portrait, 1840.

2006; *oil and acrylic on canvas*
60 x 60 inches

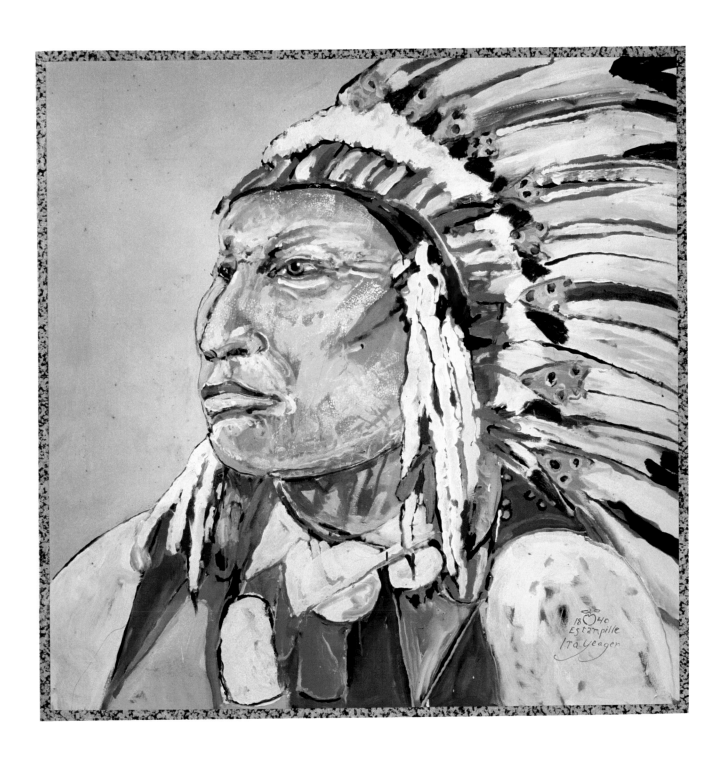

Indian Portrait: Indiens des Plains 1865-1867
2006; oil and acrylic on canvas
66 x 66 inches

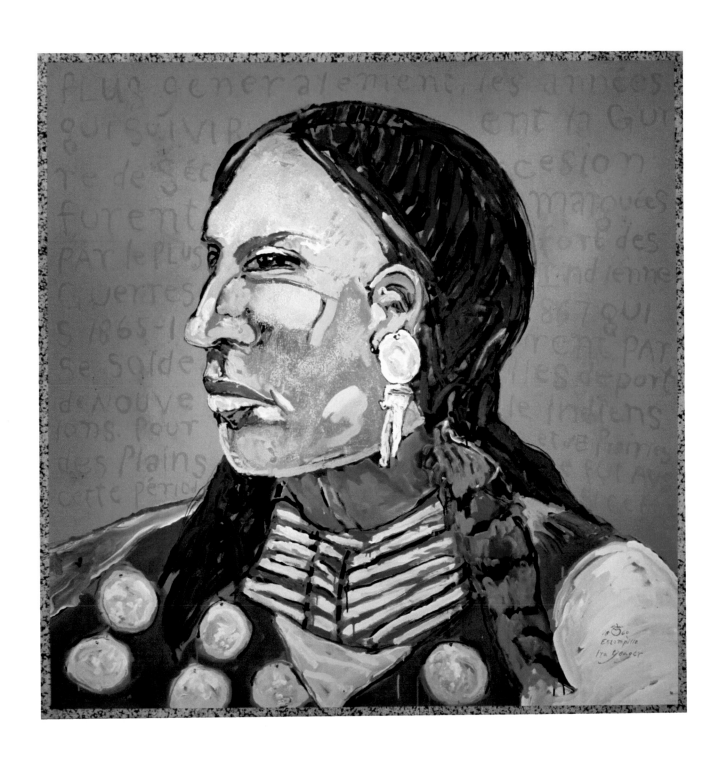

"Following the chiefs came the young men. They were
prepared for the dance much as was Kukúsim, their bodies
painted according to fancy, their hair decorated with feathers.
Their blankets they carried on their arms: to wear them
would hide from sight their beautifully painted bodies."

Indian Portrait
2002; *oil and acrylic on canvas*
60 x 60 inches

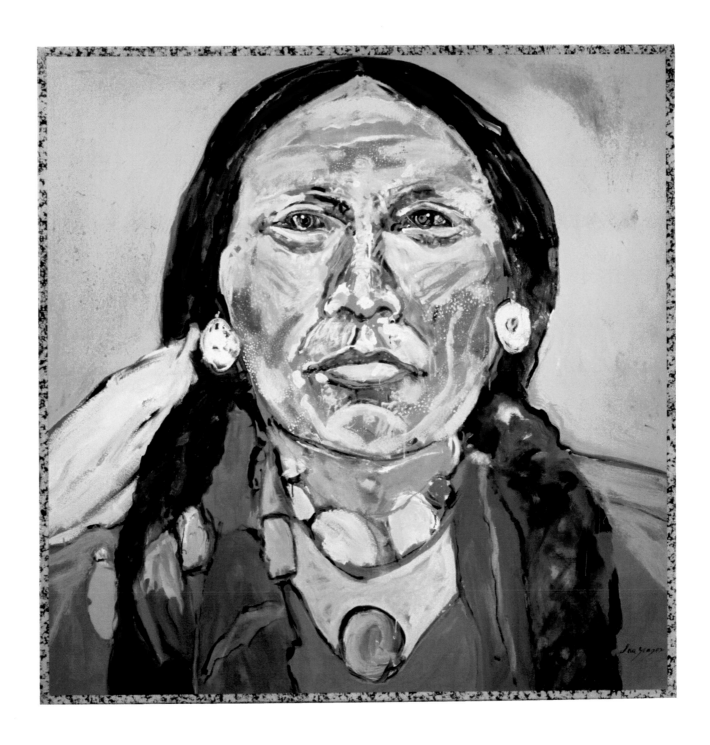

Indian Portrait

1995; *oil and acrylic on canvas*
60 x 60 inches

Collection of Dr. and Mrs. Ward Noble

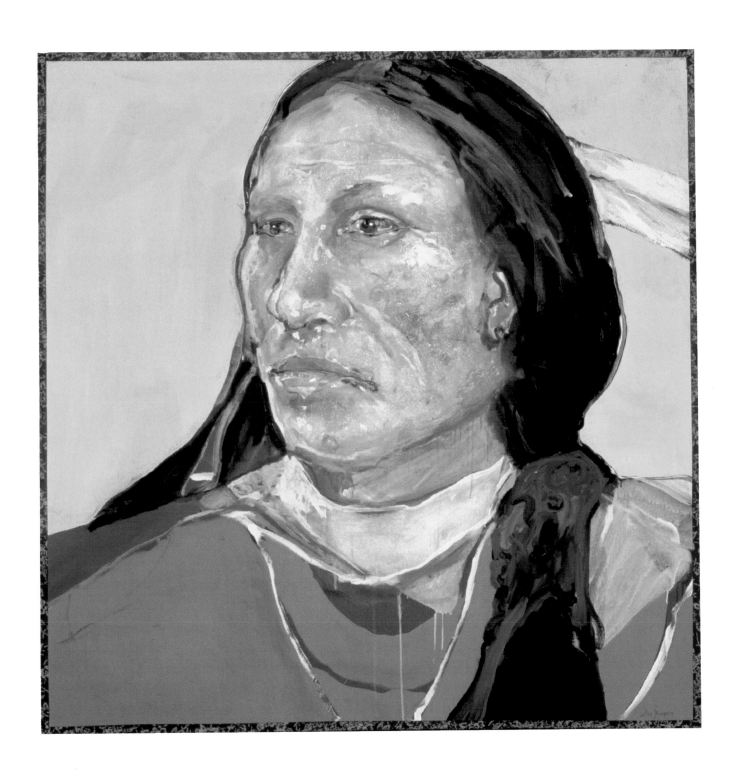

"The wives and maidens of the Hopi have soft voices, and make glad the eye with their bright faces and happy smiles."

Indian Portrait: Hopi Maiden
1995; *oil and acrylic on canvas*
24 x 24 inches

Collection of Dr. and Mrs. Ward Noble

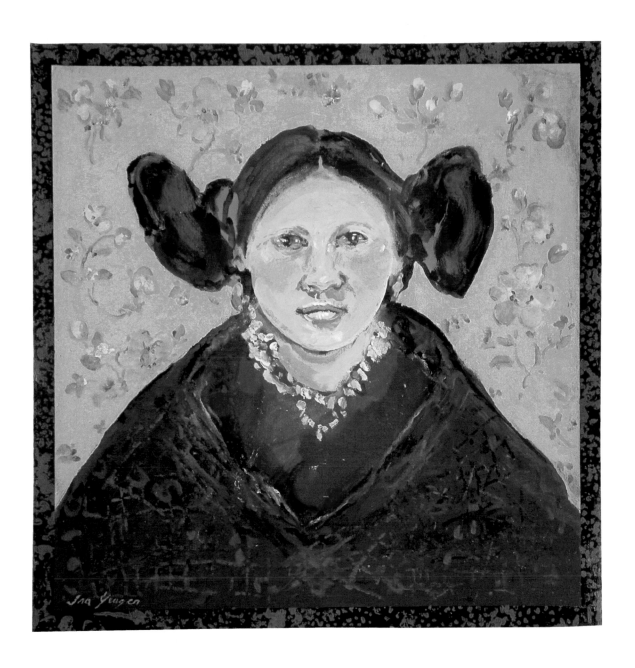

Indian Portrait: Woman with Buffalo Headdress
2000; *oil and acrylic on canvas*
60 x 60 inches

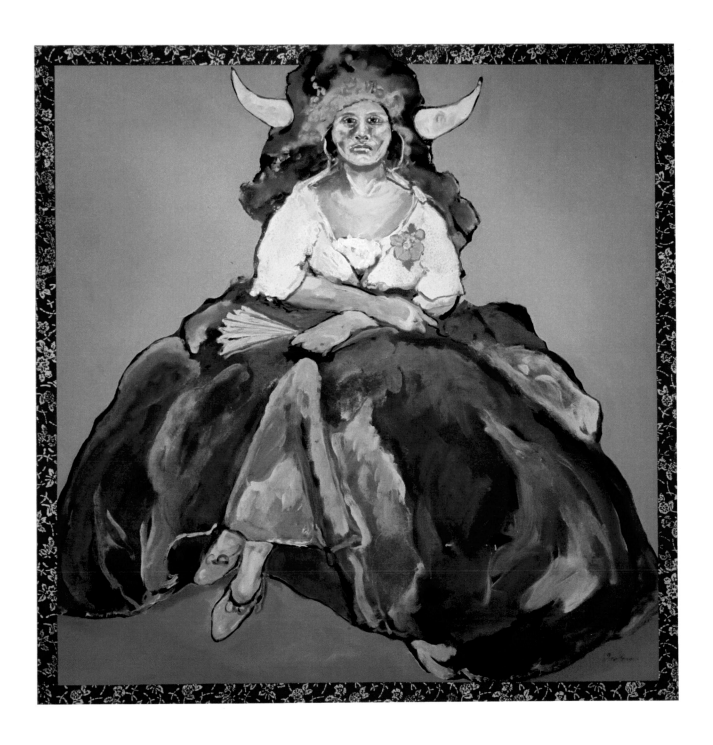

Untitled
1988; *oil and acrylic on canvas*
36 x 24 inches

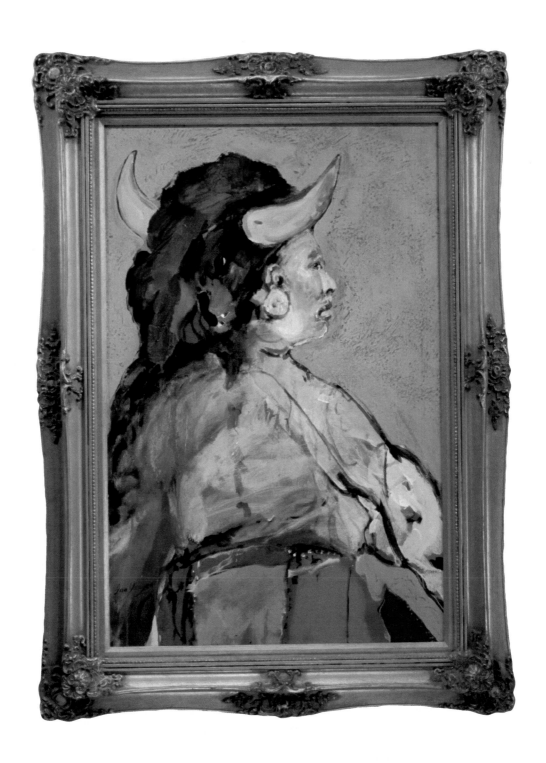

Indian Portrait with Buffalo Headdress 1795.

2002; *oil and acrylic on canvas*
24 x 30 inches

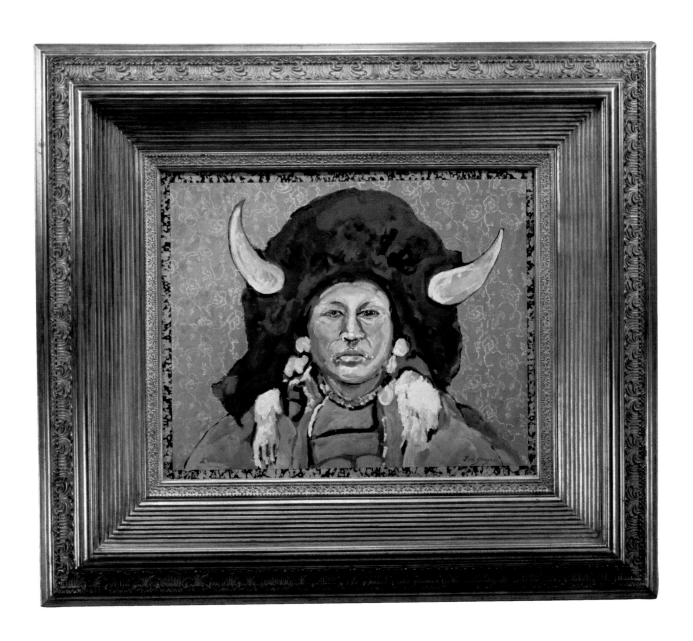

Indian Portrait: Chief with Headdress

1989; *oil and acrylic on canvas*

36 x 36 inches

Provenance: Mr. and Mrs. Joe Montana

Collection of Mr. and Mrs. David Penrice

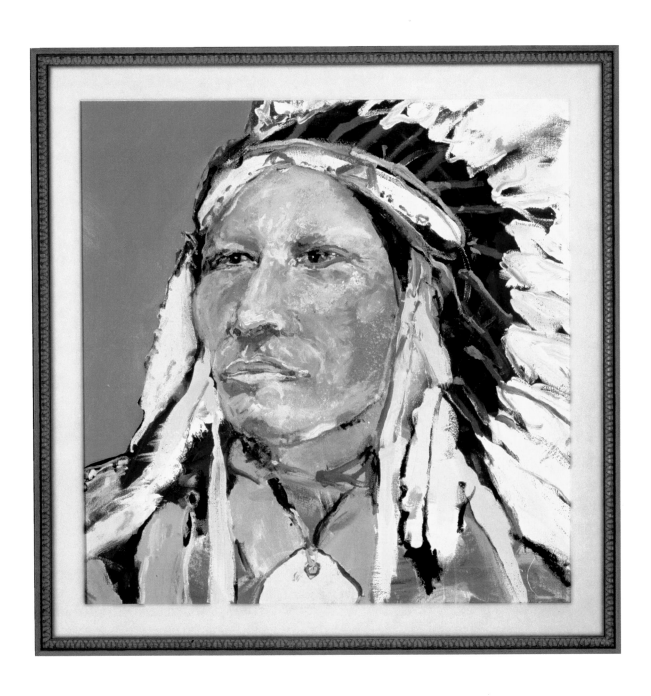

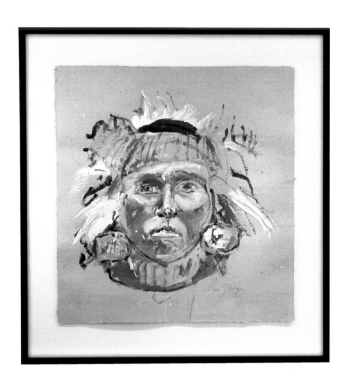

Indian (Working Drawing)
2003; *acrylic, pastel, pencil and chalk on paper*
30 x 30 inches

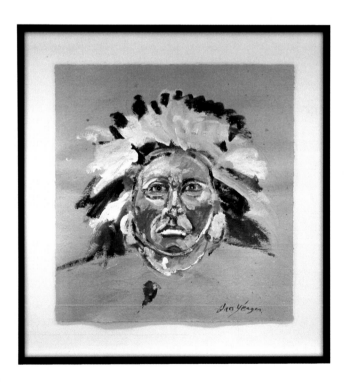

Indian (Working Drawing)
2003; *acrylic, pastel, pencil and chalk on paper*
30 x 30 inches

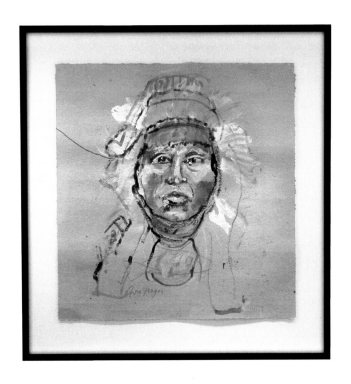

Indian (Working Drawing)
2003; *acrylic, pastel, pencil and chalk on paper*
30 x 30 inches

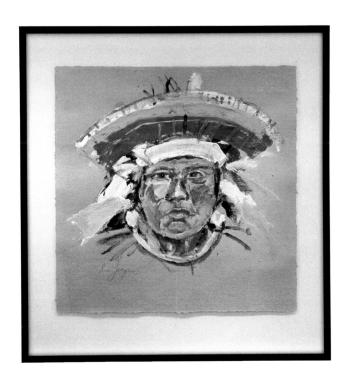

Indian (Working Drawing)
2003; *acrylic, pastel, pencil and chalk on paper*
30 x 30 inches

"The spirits come and speak to him, and teach him songs which will give him strength throughout his life. This is their way, and they believe that so long as it is followed they will be a powerful nation. That is the end."

Indian Portrait (Chief)
2006; *oil and acrylic on canvas*
60 x 60 inches

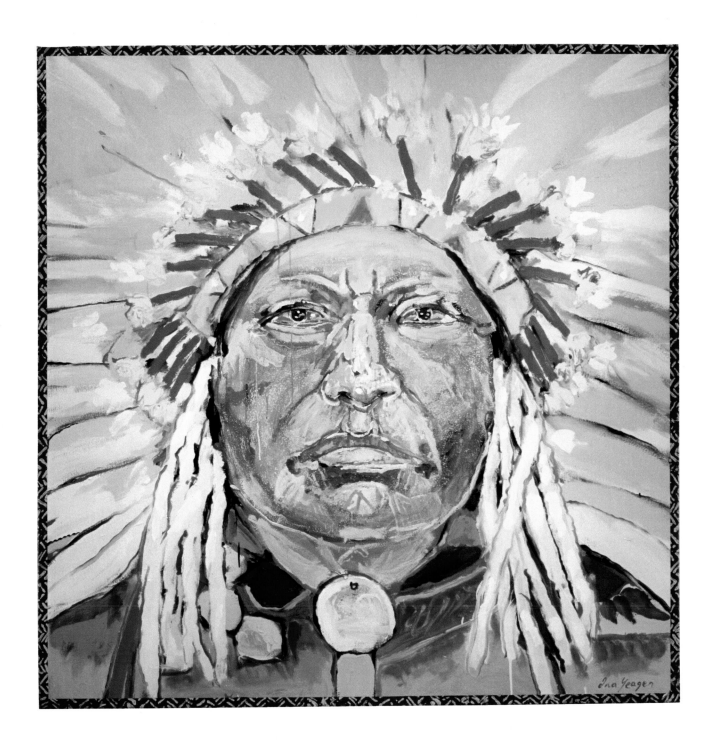

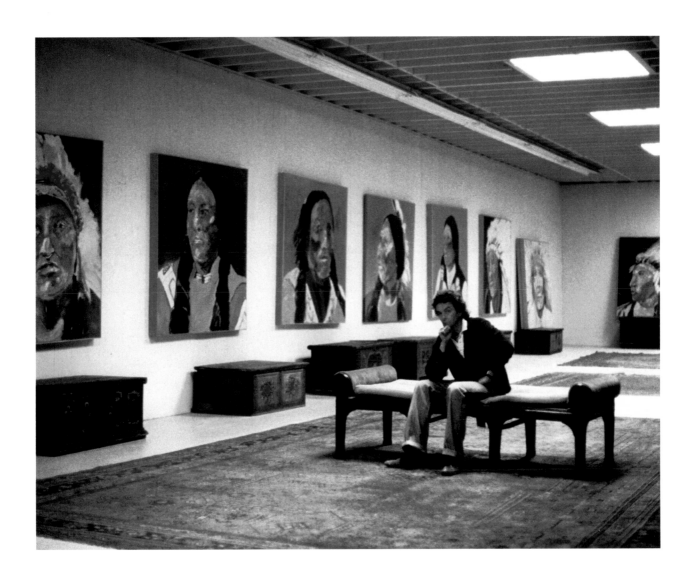

Shotwell Street Studio, 1976

Ira Yeager as a Self-Critic

There are those who talk about the things they do and those who do things and those who do both and those who do neither. In the artistic world, bullshit abounds, though it usually goes by more polite names. When artists like Ira Yeager perform unique alchemy upon simple materials such as canvas and pigment, producing new objects and worlds that permit us to see things in new and different ways, we cannot be blamed for wanting to know what – if anything – lies behind it. What were they trying to do? What is the point? Why did they do it?

Some can do a passable job of explaining their work, without any necessary relevance to their accomplishments and importance as artists. We'll never know whether their explanations are, in fact, clear windows into the creative process or after-the-fact rationalizations. Certainly, if artists do not do this themselves, there are legions of critical voices eager to ride their masterly coattails into the realms of pseudoscientific explanation.

As for Yeager, he's not a self-conscious, calculating artist, but one who when most deeply engaged in his art approaches becoming it. The state of flow and exuberance which best characterizes his personality and is captured in his best work is incompatible with glib pronouncements about it. He produces astounding effects and makes artistic choices in service of the creative act and object, perceiving and acting in a symbiotic fashion while making his paintings work. If fine and exacting judgment is an inextricable part of his work itself, it leaves little room for pontification or lecturing us about it. In *Anatomy of Criticism*, Northrop Frye states, "The artist, as John Stuart Mill saw in a wonderful flash of critical insight, is not heard but overheard. The axiom of criticism must be not that the poet does not know what he is talking about, but that he cannot talk about what he knows." Yeager leaves that pleasurable, but quite different, task for others – the rest of us, external to his work though graciously invited in.

What may seem like inarticulateness is in fact a deep and abiding reluctance to diminish and fragment the unity of what was produced. It is as if a mother were asked to describe her child in terms of chemical constituents, proportions, or the purpose of her child's shape or smell or features. Some mothers may be able to do this, perhaps as a parlor trick, but the very process would be tantamount to "deconstructing" (to use an already controversial term from the world of literary analysis) her beloved whole.

In the process of creation, Yeager reports he'll sometimes first create "imbalance" if it does not already exist, which stimulates his creative energies to either join the imbalance and its inherent movement, or oppose the imbalance's force. Inherently, this betrays an underlying meaning and purpose in his work, as a "correction" or "fixing" of reality, even as he remains free of theorizing, refusing to throw glib intellectualizations to critics and students of his oeuvre.

J.J. RUSS

I romanticize the Indian. I think of them the same as I think of the court of Louis XVI. Beautiful feathers, fur and jewels…

Some ask if there is a magical philosophy why I paint Indians. It is a tool to use – of use for color exercises like a pianist does scales, like an architect builds a house. I paint music like a symphony or an opera. A successful Indian painting is like a Verdi – triumphant march. Repetition of images is like learning to play a perfect song. If I could play a perfect song, it would be Beethoven's "Moonlight Sonata." Yes, I have done some virtuoso Indians in 40 years. Only the viewer would know.

IRA YEAGER

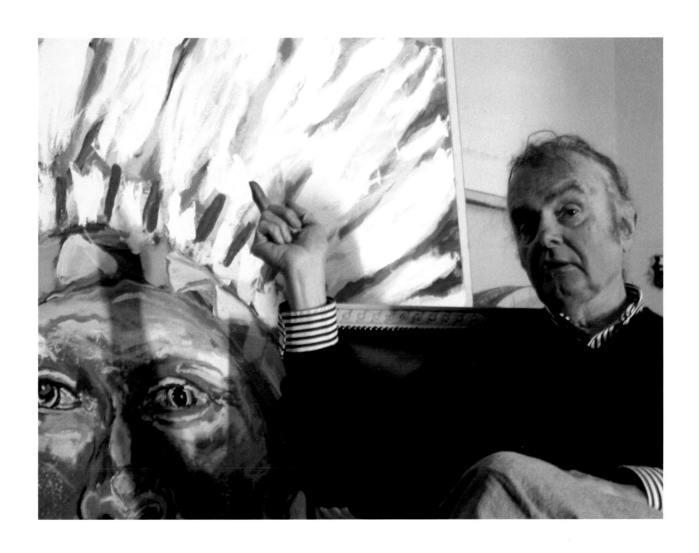

Napa Valley Studio, 2006

Bibliography

CURTIS, EDWARD S. *Indian Days of the Long Ago.*
Yonkers-on-Hudson, NY: World Book Company, 1915.

WOLLHEIM, RICHARD. "The Pictoral World of Ira Yeager."
Ira Yeager: A Retrospective Exhibition. San Francisco, CA:
Napa Valley Museum and Studio: Ira Yeager, 1999.

With great appreciation, I would like to first of all thank the noted collectors that kindly agreed to participate in the publication of this book. I also would like to acknowledge Barry Low at Studio Bear Designs, Ira Schrank of Sixth Street Studio, Robert Flynn Johnson, Gary B. Carson, Sven Bruntjen, Jennifer Strong and Lainey S. Cronk for their help in making this book a reality. I would also like to especially thank Jennifer Jackson for her assistance and technical support with production and photography.

B.F.